EUGÈNE DELAC

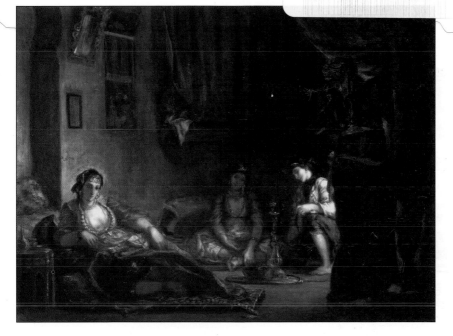

Published by TAJ Books International LLC 2014
5501 Kincross Lane
Charlotte, North Carolina, USA
28277

www.tajbooks.com
www.tajminibooks.com

ISBN 978-1-84406-322-2 Hardback
978-1-62732-001-6 Paperback

Printed in China

1 2 3 4 5 18 17 16 15 14

EUGÈNE DELACROIX

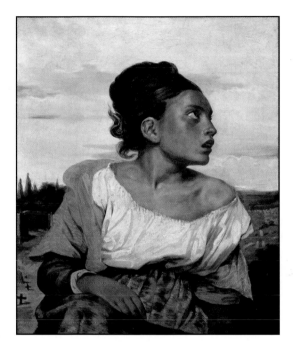

T&J

ISABELLA ALSTON

EUGÈNE DELACROIX

Ferdinand Victor Eugène Delacroix, better known simply as Eugène Delacroix, was highly influential in the 19th-century Romanticism art movement and is considered by many art historians to be the most important of the Romantic painters. His work emphasized the creative and imaginative aspects of the individual, focusing on the use of art as a means of self-actualization and self-realization. Romanticism reflected the newly emerging concept that an individual could only ever fully find self-awareness if able to separate themselves from society. Society only enabled the individual to philosophically advance and develop to a limited degree, and thus the individual had to search for enlightenment and understanding beyond the confines of society. Delacroix is often attributed with refining Romanticism, not only aesthetically but philosophically as well, for it was a movement not only in art, but also in literature. As a result, Delacroix's contribution to art simultaneously influenced all the liberal arts of the time.

Delacroix was born in Charenton-Saint-Maurice on the Ile-de-France, just outside Paris. His mother, Victoire, was the daughter of Jean Francois Oeben, a well-known French cabinetmaker. It is thought that Delacroix was actually the illegitimate son of the famous French diplomat, Talleyrand. Delacroix strongly physically resembled Talleyrand and was protected throughout his life by him, particularly so after he was orphaned at the age of 16. An additional consideration in terms of Delacroix's paternity is that Victoire's husband, Charles-François Delacroix, also a diplomat, is commonly viewed as having been unable to father children. He preceded Delacroix's mother in death by nine years. Talleyrand's oversight was of particular importance because Delacroix's birth coincided with the birth of the tumultuous French Revolution, which endured for the first 20 years of Delacroix's life.

Delacroix attended the Lycee Louis-le-Grand in Paris, a notoriously rigorous school. He then continued his education at the Lycee Pierre Corneille located in Rouen, France. This school catered to children of aristocrats and the upper class, further suggesting and supporting the notion that Talleyrand was Delacroix's biological father. Delacroix performed exceedingly well at both schools, focusing on his studying and winning numerous awards for his art and drawings. After graduation he was tutored by the classically trained Pierre-Narcisse Guerin, a successful and well-known French artist of the time, who worked in the Neo-classical

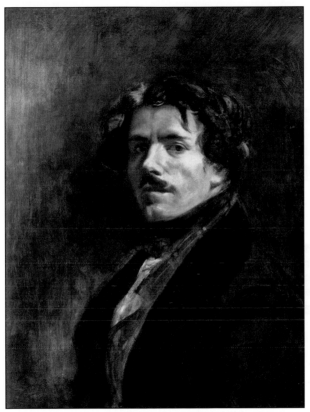

Self-portrait, 1837
Oil on canvas, 65 x 54 cm
Musée du Louvre, Paris

style, a forerunner of the Romantic movement. Therefore, much of Delacroix's early work was highly influenced by Neo-classical painters, yet as he progressed in maturity and experience his unique style began to emerge. Artists in other fields, such as Chopin in music, who were reknowned for their contributions to the Romantic movement were also a major influence on Delacroix during these formative years.

An early painting, *The Barque of Dante*, was accepted by the Paris Salon in 1822. *Orphan Girl at the Cemetery*, painted in 1823 and 1824, is believed to be a precursor to his larger work, *Massacre at Chios*. Regardless of the motivation for the work, art historians consider *Orphan Girl at the Cemetery* a masterpiece in its own right. The girl is looking up and into the distance in fear, her emotions translated effortlessly to the viewer. Her figure and stance speak of utter vulnerability, inviting immediate sympathy. The dark and dim coloring of the landscape in the background magnifies the loss, despair, hopelessness, isolation, and fear of the unknown that is so well conjured by her image and is a good example of Delacroix's sophisticated use of chiaroscuro in many of his paintings.

Another early internationally recognized work by Delacroix is the 1824 painting *Massacre at Chios*, which depicts the Greeks being killed by the Turks. It too was exhibited at the Paris Salon. At this time, the Greek people were seeking independence from the Turks, deeply entrenched in a war for independence. Delacroix's work showed his sympathy for their plight, a fight the French people understood well having been involved in their own revolutions against oppression. The French state was so moved by his work that it was purchased and displayed for all to see. It is currently hung at the Musée du Louvre in Paris. This evocatively emotive work is one of the first examples of Delacroix becoming the leading painter of the Romantic style. Many critics disliked the piece because they felt that the tone of the work was too depressing and dark, going so far as to call it a "massacre of art." Despite this, the controversy the work provoked only garnered more attention for Delacroix, thus helping rather than hurting his career.

After *Massacre at Chios*, Delacroix painted a second work, *Greece Expiring on the Ruins of Missolonghi,* in 1826 that also portrayed the Greek war for independence. The central figure in this piece is a female figure robed in white wearing a blue coat with a red scarf tied around her waist. The robe she wears is open in the front, revealing her bare chest. She stands, symbolizing Greece, in the midst of chaos and destruction. Her arms are open in a gesture both questioning and horrified.

The scene she beholds is unnecessary ruin and destruction, a product of ceaseless fighting and human misunderstanding. Near the bottom of the painting a hand protrudes from the rubble, emphasizing the excessive suffering caused by human hate. In general, critics describe the work as a monument to the people of Missolonghi and their struggle against the tyrannical rule of the Turks. Delacroix was interested in this subject not only because of his natural French empathy, but also one of his favorite poets, Lord Byron, died there.

In 1825 Delacroix traveled to England, bringing back with him the English use of coloring and portraiture. Perhaps his most exemplary work in this style is the portrait of Louis-Auguste Schwiter. Appropriately, the painting now hangs in the National Gallery in London. During this period Delacroix also produced numerous monochromatic lithographs or prints as book illustrations. Lithography was a popular means of mass-producing artwork, not only to earn money but also as a means of self-promotion. During his career, Delacroix illustrated the literary works of numerous authors, including William Shakespeare and Goethe, using the lithographic process.

Delacroix's work in the 1820s was filled with themes of sexuality and violence. Examples include *The Combat of the Giaour and Hassan* (1826) and *Woman with a Parrot* (1827). Delacroix based the former on the poem by Byron. The story of the poem and the painting is about a Venetian infidel who fights the Muslim, Hassan, in order to avenge the death of his lover whom Hassan murdered after she fled his harem. Delacroix's painting shows the struggle between the two protagonists as if their actions were freeze-framed in time. He captures them in the moments before striking with their weapons, seated astride their stallions, creating a dynamic atmosphere within the frame. They mirror each other in pose. In the work, Delacroix channels the earlier Baroque painting style, but adds a modern twist with looser brush strokes and freer interpretation of the subject matter. The painting is reminiscent of Rubens' style, although Delacroix has implemented the 19th century's use of complementary colors and chiaroscuro, inserting shadows to emulate and enhance the emotional aspects of the work.

Death of Lara, which dates from the mid-to-late 1820s, and is currently in the collection of the J. Paul Getty Museum in Los Angeles, was also inspired by a Byron poem. In the watercolor, a woman robed in a blue gown with red sash and a tartan shawl wears a small military cap. She is looking down in sadness and despair, grieving for the fallen soldier who lies prone and stiff at her feet. *Death of Lara* was inspired by the poem "Lara"

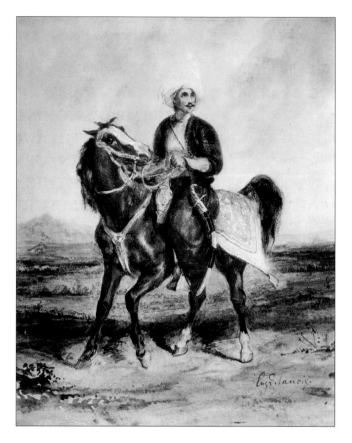

Turkish Horseman, c. 1825
Watercolor on paper, Dimensions unknown
Private Collection

by Lord Byron that was published in 1814. The poem tells the tale of a Spanish overlord named Lara who led a peasant revolt, which was thwarted by the hostile baron Otho. Lara was wounded by an arrow in battle and died, but was cared for faithfully by his compatriot, Kaled. The twist to the story is that Kaled is a female disguised as a man in order to more easily travel and accompany her lover, Lara. Delacroix's ability to expound on the element of love and loss at the end of the poem lends a mournful air of romance to the illustration and is a fine example of his talent for visually interpreting the written word. His refined use of color helps create the rich detail and emotional contrast of the story, evoking the true spirit of the original literary work.

One of Delacroix's best-known paintings is *Liberty Leading the People* (1830), which represents the Parisian people in their search for liberty, fraternity, and equality, a subject of great importance to the French nation on the heels of their successful revolution. This work was highly influential in an artistic sense because it highlighted the differences between Neo-classicism and Romanticism. The painting captures the French citizens as they take their weapons in hand and march forward, led by the physical representation of Lady Liberty. Although soldiers lie dead on the ground, the dark tone is overpowered by the welcome feminine spirit of Liberty as she marches

forward on her quest. The French government also bought this work, but did not immediately display it publicly because the subject matter was believed to be too provocative. Despite this, Delacroix received numerous commissions from the French government as a result of the work. After the Revolution of 1848, which led to the election of the new French president, Louis Napoleon, the painting was put on display. Today, the work is on display at the Musée du Louvre.

A Young Tiger Playing with Its Mother (1830) is an example of Delacroix's choice of animals rather than humans as subjects. Many critics believe that this work was inspired by one of the painter's visits to the Jardin des Plantes in Paris, although it is also thought that his pet cat served as a model and perhaps inspiration for the image. The influence of Rubens, whom Delacroix greatly admired, can be seen especially in the contrasting tenseness/tenderness between the two creatures, mother and child. The softer side of what is generally characterized as an untamed, dangerous animal dominates the painting. Interesting to note, a later work of Delacroix, *Tiger Hunt* (1854), captures a very different spirit in the felines, one of anger and ferocity. Thus, Delacroix is able to understand and to portray the innately sensual and tender side of these creatures in his artwork alongside their natural aggressiveness. The emotions that he so well

captures in his human subjects are shown to be just as viable for creatures in the wild.

In 1832, Delacroix traveled to North Africa and Spain as part of a diplomatic mission to Morocco after the French acquisition of Algiers. He went not only to find artistic inspiration, but as a means of escaping what he found to be a stifling society in Paris. Delacroix wished to immerse himself in a more primitive—socially and physically—environment to find new energy and subjects from which to create art. He produced over 100 works based on his experience in Morocco, furthering a new trend in art called Orientalism. The people and dress of the North African culture were of great interest to Delacroix and continued to play an influential role in his paintings throughout his life.

The Women of Algiers in Their Apartment was completed in 1834 during Delacroix's time in North Africa. It is currently on display in the Musée du Louvre. Prior to Delacroix's death, the painting had been displayed in the Musée du Luxembourg. The most prominent theme in the painting is sexuality, most obviously because of its subject: Algerian concubines. The three women in the painting are seated on the floor in a harem surrounding a hookah, then the most popular device with which to smoke hashish or opium. In addition to the subject of sexuality, the clear suggestion of controversial substance abuse made it a highly provocative piece especially when such things were not openly discussed among members of high society. Later Impressionist, Post-Impressionist, and even Modernist painters drew much inspiration from this work. For example, Pablo Picasso produced up to 15 variations on the theme. Perhaps the painting even served as an inspiration for his much beloved *Les Demoiselles D'Avignon.*

It has been noted in more recent years, that *The Women of Algiers in Their Apartment* is quite different from what an Algerian harem would have looked like almost 200 years ago. Delacroix placed the women lounging luxuriously and idly amid rich fabrics, whereas the reality would have entailed children and much more activity in the scene. It appears that Delacroix truly did romanticize the scene, most likely in an effort to appeal to the European sensibilities surrounding the orient and the exotic "unknown."

Despite artistically adopting North Africa, Delacroix made note of the fact that he strongly believed the countries in this part of the world were in need of serious social and political reform. He felt the people who lived in North Africa were repressed and lacked certain basic human rights that Europeans and Americans took for granted. Due to the strict rules of the Islamic religion, Delacroix was forced to find unconventional ways to observe his subjects, mainly women, drawing and

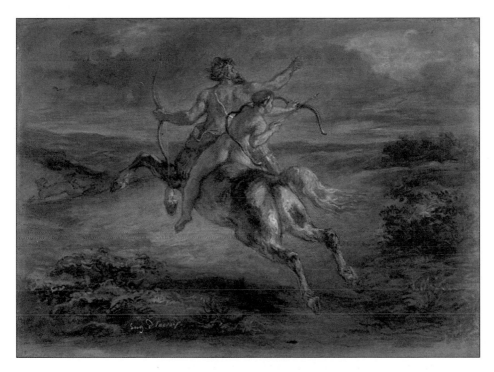

The Education of Achilles, c. 1862
Pastel on paper, 30.64 x 41.91 cm
The J. Paul Getty Museum, Los Angeles

painting them by essentially spying on them. These strictures meant that much of his work during his North Africa period predominately depicted men, as well as animals, solely because they were the subjects most at hand. Delacroix did have some luck finding female models of the Jewish religion, thus he was able to produce two well-known works, *A Jewish Wedding in Morocco* (c. 1839) and *The Jewish Bride* (1832).

The following year, Delacroix received several commissions from the French government to paint murals on buildings in Paris. One of his most famous was commissioned for the Salon du Roi (King's Salon) in the Palais Bourbon and took over four years to complete. He also painted the façade of the Church of St. Denis du Saint Sacrement as well as the Galerie d'Apollon in the Louvre. From 1857 to 1861, he painted several murals at the Chapelle des Anges at St. Sulpice. These years of backbreaking work exhausted Delacroix both physically and mentally, making him susceptible to illness. He would occasionally visit his country home in Champrosay to get away from the city and find respite among nature. During these more difficult years, and in his failing health, he was cared for with great dedication by his housekeeper, Jeanne-Marie Guillou, an important figure in his life. Delacroix never married and had no acknowledged children.

Without Madame Guillou's care and devotion, he probably would not have been able to continue working as long as he did.

Between murals, Delacroix, always quite prolific, sketched *The Education of Achilles* (1844). Here Chiron, a centaur, is teaching the god Achilles how to hunt with a bow and arrow. Both figures are depicted in similar poses, bodies facing in the same direction to suggest the emotional closeness between the two. A great amount of power is captured in the lines of the work, which direct the energy beyond the canvas and signal the force that will eventually take the arrow outside the image's border. This drawing was a preliminary sketch executed during the research phase for Delacroix's commission at the Palais de Bourbon. The final mural at the Palais included the themes of Philosophy, Science, Poetry, Law, and Theology. All of these themes were of primary importance during the Classical Greek period, as well as the primary focus of the Romantic movement. Not only did the Romantics seek to embody emotion and understanding of the individual through artistic means, they also were greatly interested in how to explore these subjects via scientific understanding.

A wonderful example of the stimulation Delacroix took from his travels in North Africa and Spain and that remained with him for the balance of his career and life is

the *Moroccan Horseman Crossing a Ford* (c. 1850). Although back in Europe at the time he produced this painting, he drew upon the great amount of sketches and watercolors that he prepared while in North Africa in order to preserve his memories. A horseman, such as the subject of this painting, was one of Delacroix's favorite characters discovered during his travels. The horseman's exotic and vibrantly colored dress as well as strong sense of movement captivated Delacroix's artistic sensibilities. In addition to the visual arts, Delacroix recorded his thoughts on paper. He explained that he perceived these horsemen as "living incarnations of the noble spirit" and that they embodied the strength of the "heroes of antiquity." The painting is small in size and was created for self-study and thoughtful reflection rather than meant to be a grand work. It is a good example of the exotic and fantastical side to Delacroix's vision and to his art.

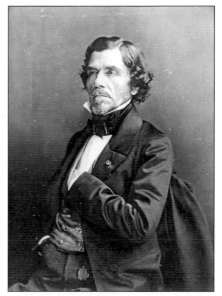

Photograph of Delacroix later in life by Felix Nadar

In 1862, Delacroix helped found the Société Nationale des Beaux-Arts in Paris. Many influential painters and writers of the time were involved in this society. But soon after, in 1863, Delacroix died. A year after his death, the Society exhibited 248 of his paintings and lithographs; the Society would never hold another exhibition. Delacroix is buried in Père Lachaise Cemetery in Paris. Much of his work remains in French institutions. The Museum Eugène Delacroix is housed in a small building attached to the Musée du Louvre in Paris. Delacroix was the leader of the Romantic movement and encouraged its adoption among his contemporaries. His work and vision opened the door to the next great artistic movement, Impressionism.

Plate 1

THE ITALIAN THEATRE
1821, Musée Eugène Delacroix, Paris
21.5 x 19.6 cm, Lithography

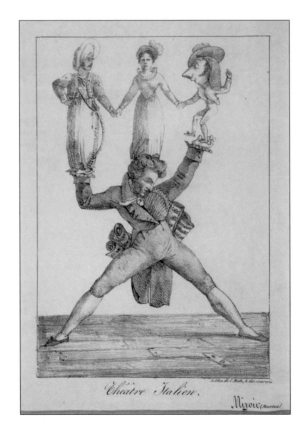

Plate 2

THE BARQUE OF DANTE
1822, Musée du Louvre, Paris
189 x 241.5 cm, Oil on canvas

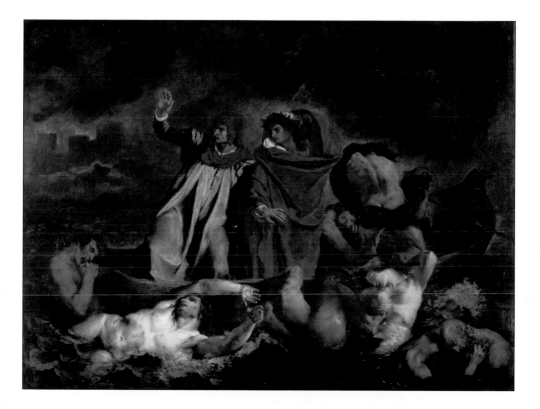

Plate 3

ORPHAN GIRL AT THE CEMETERY
c. 1824, Musée du Louvre, Paris
65 x 55 cm, Oil on canvas

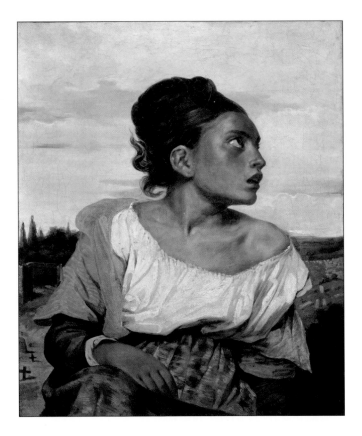

TWO KNIGHTS FIGHTING IN A LANDSCAPE

Plate 4

c. 1824, Musée du Louvre, Paris
81 x 105 cm, Oil on canvas

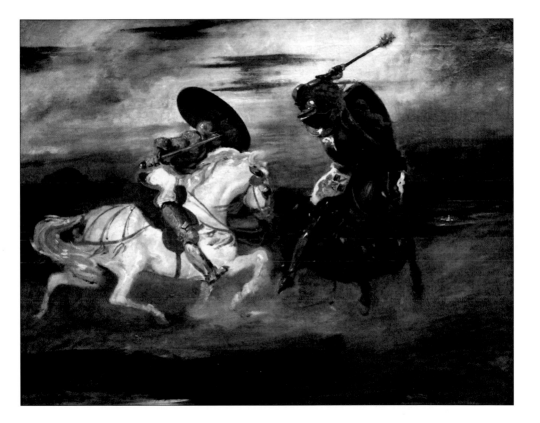

Plate 5

MASSACRE OF CHIOS
1824, Musée du Louvre, Paris
419 x 354 cm, Oil on canvas

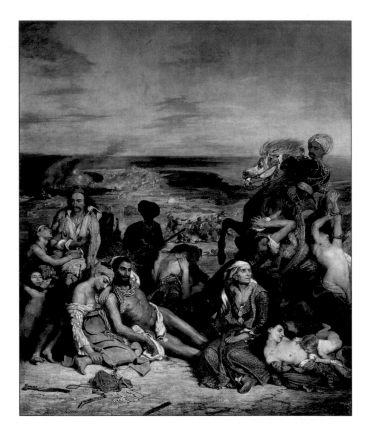

SEATED NUDE, MADEMOISELLE ROSE

1824, Musée du Louvre, Paris
81 x 65 cm, Oil on canvas

Plate 6

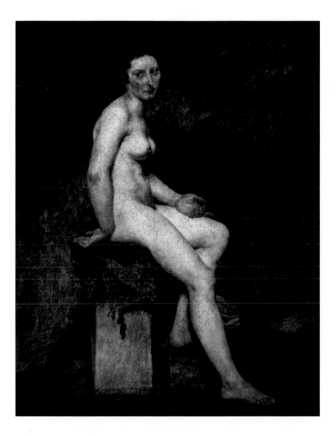

Plate 7

A MORTALLY WOUNDED BRIGAND
QUENCHES HIS THIRST

1825, Kunstmuseum Basel, Switzerland
32.7 x 40.8 cm, Oil on canvas

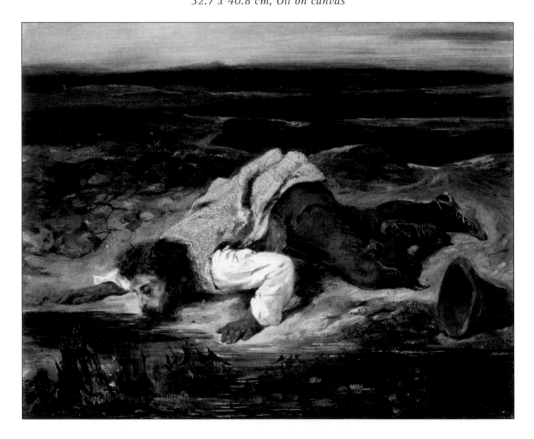

GREECE EXPIRING ON THE RUINS OF MISSOLONGHI

Plate 8

1826, Musée des Beaux-Arts, Bordeaux, France
208 × 147 cm, Oil on canvas

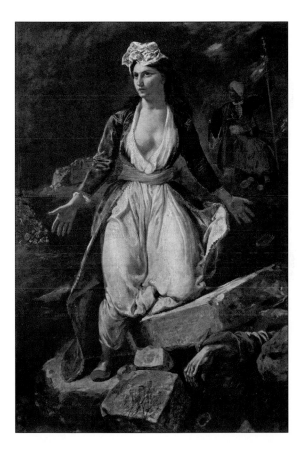

Plate 9
THE EXECUTION OF THE DOGE MARINO FALIERO
1825–26, The Wallace Collection, London
145.6 x 113.8 cm, Oil on canvas

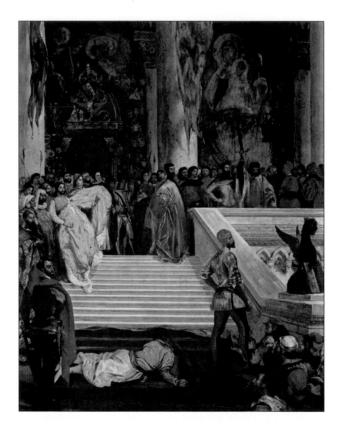

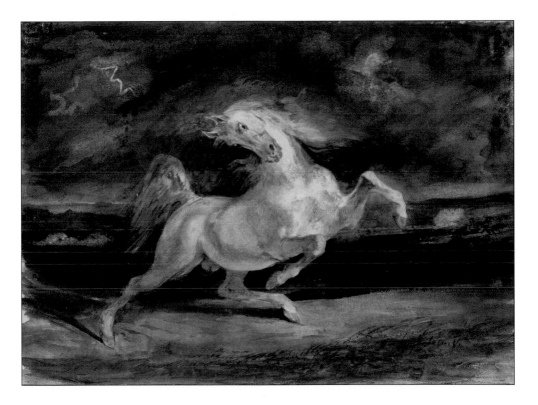

HORSE FRIGHTENED BY LIGHTNING

Plate 10

c. 1825–29, Museum of Fine Arts Budapest
23.6 x 32 cm, Watercolor and lead white on paper

Plate 11

FEMALE NUDE RECLINING ON A DIVAN

c. 1825–30, Musée du Louvre, Paris
26 x 33 cm, Oil on canvas

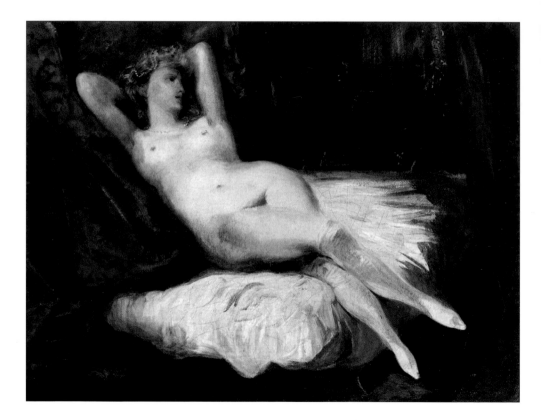

THE COMBAT OF THE GIAOUR AND THE HASSAN *Plate 12*

1826, Art Institute of Chicago
59.6 x 73.4 cm, Oil on canvas

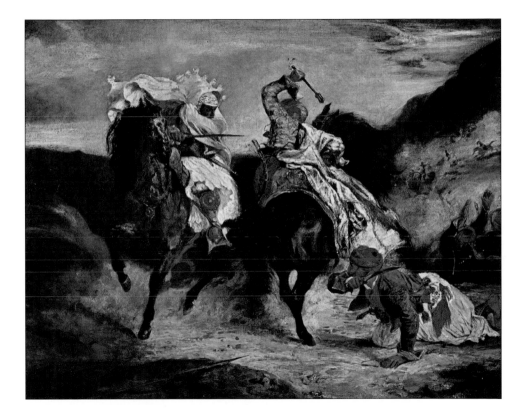

Plate 13

PORTRAIT OF A TURK IN A TURBAN
c. 1826, Musée Eugène Delacroix, Paris
47 x 38 cm, Pastel on paper

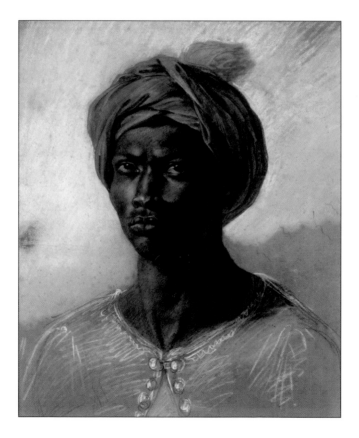

STILL LIFE WITH LOBSTERS

Plate 14

1826–27, Musée du Louvre, Paris
80.5 x 106.5 cm, Oil on canvas

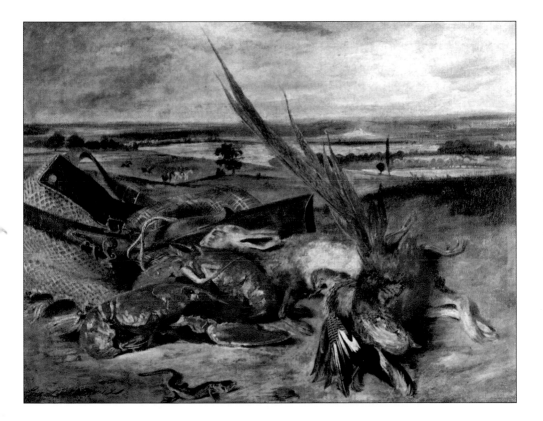

Plate 15

LOUIS-AUGUSTE SCHWITER
1827, The National Gallery, London
217.8 x 143.5 cm, Oil on canvas

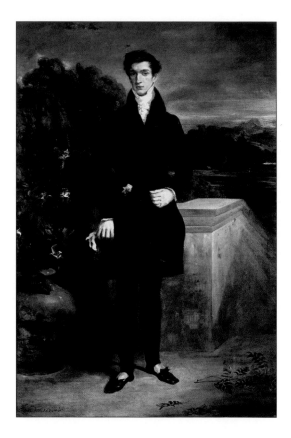

THE DEATH OF SARDANAPALUS

Plate 16

1827, Musée du Louvre, Paris
392 x 496 cm, Oil on canvas

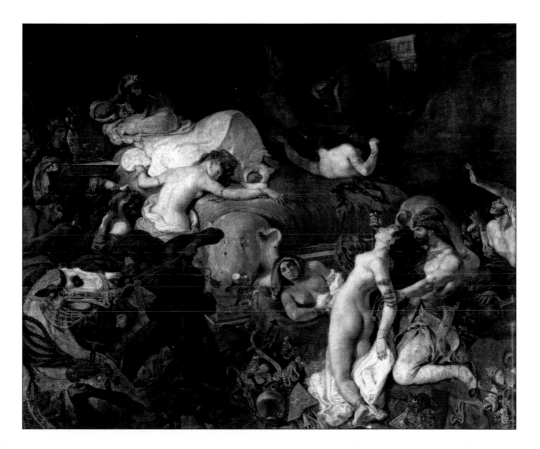

Plate 17

WOMAN WITH A PARROT

1827, Museum of Fine Arts of Lyon, France
24.5 x 32.5 cm, Oil on canvas

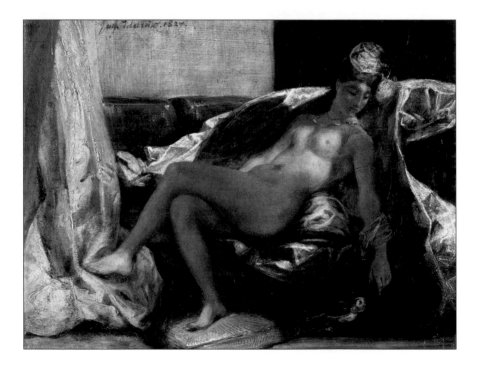

YOUNG TIGER PLAYING WITH ITS MOTHER

Plate 18

1830, Musée du Louvre, Paris
131 x 194.5 cm, Oil on canvas

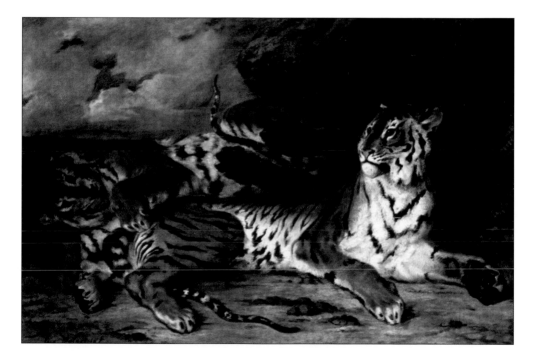

Plate 19

BATTLE OF POITIERS

1830, Musée du Louvre, Paris
114 x 146 cm, Oil on canvas

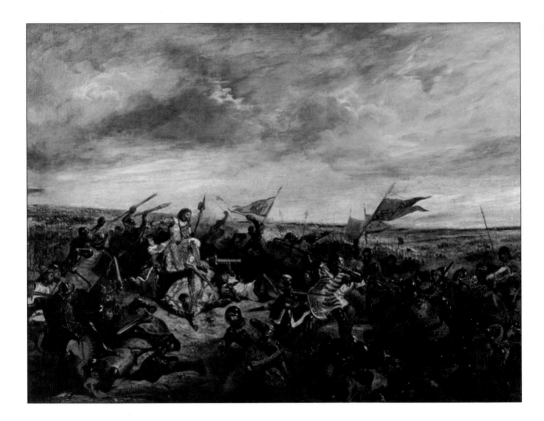

Plate 20

A CORNER OF THE STUDIO

c. 1830, Musée du Louvre, Paris
51 x 44 cm, Oil on canvas

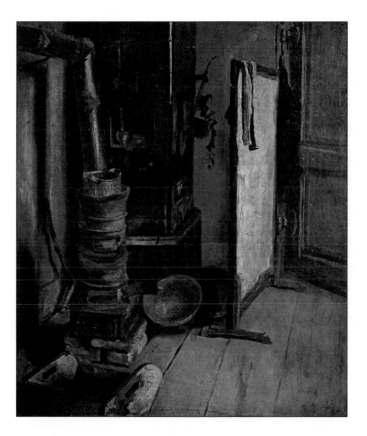

Plate 21

TIGER RESTING
c. 1830, Art Institute of Chicago
20.3 x 38.1 cm, Oil on canvas

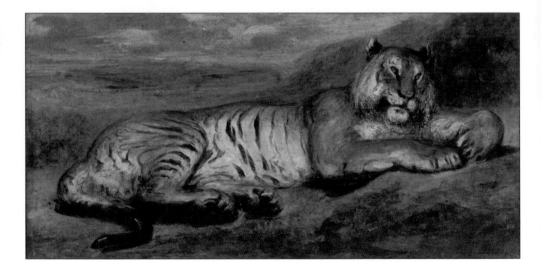

LIBERTY LEADING THE PEOPLE

1830, Musée du Louvre, Paris
260 x 325 cm, Oil on canvas

Plate 22

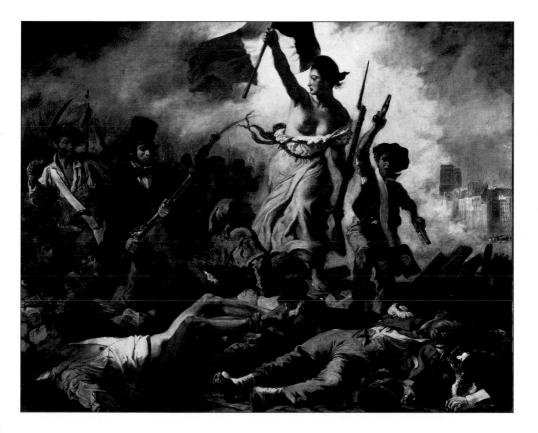

Plate 23

HEAD OF A WOMAN IN A RED TURBAN

1831, Bristol City Museums and Art Gallery, UK
41.3 x 35.3 cm, Oil on canvas

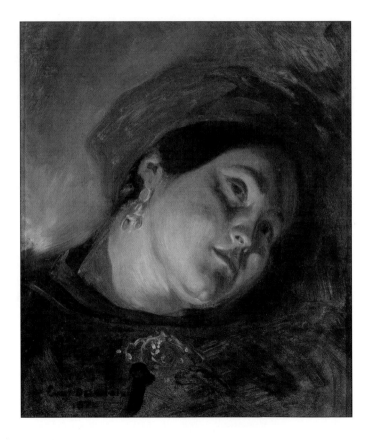

Plate 24

THE WITCHES' SABBATH
1831–33, Kunstmuseum Basel, Switzerland
32.3 x 40.5 cm, Oil on canvas

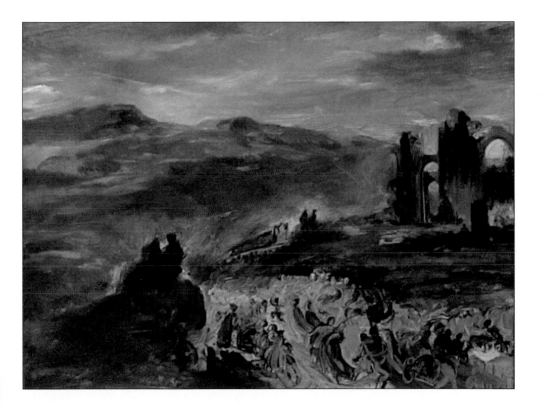

Plate 25

MOROCCAN MILITARY EXERCISES

1832, Musée Fabre, Montpellier, France
60 x 73 cm, Oil on canvas

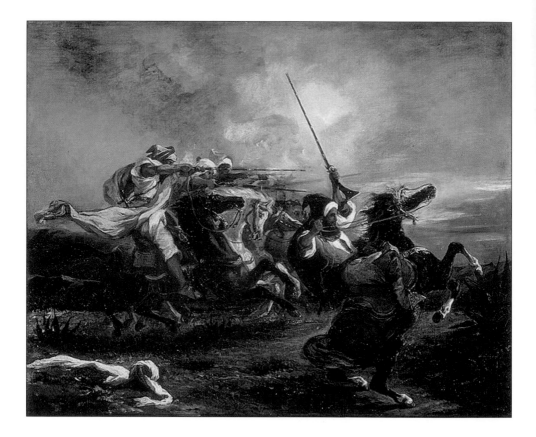

Plate 26

THE TURKISH RIDER

c. 1834, Art Institute of Chicago
25.2 x 18.7 cm, Gouache and watercolor on paper

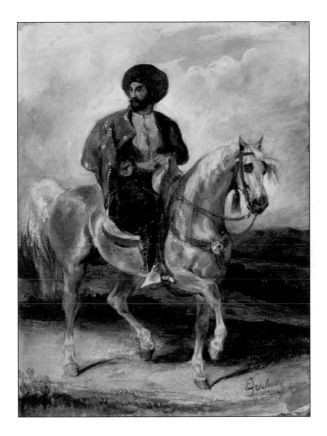

Plate 27

THE PRISONER OF CHILLON
1834, Musée du Louvre, Paris
74 x 93 cm, Oil on canvas

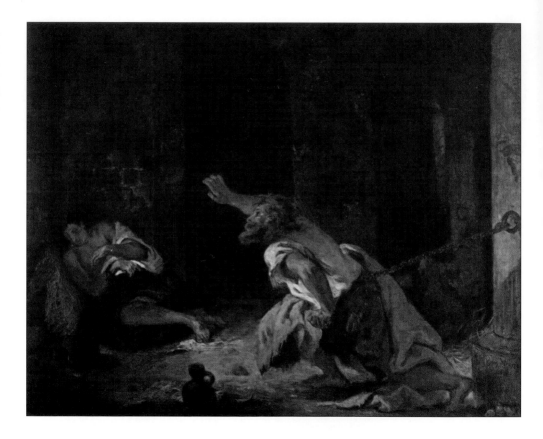

THE WOMEN OF ALGIERS IN THEIR APARTMENT *Plate 28*

1834, Musée du Louvre, Paris
180 x 229 cm, Oil on canvas

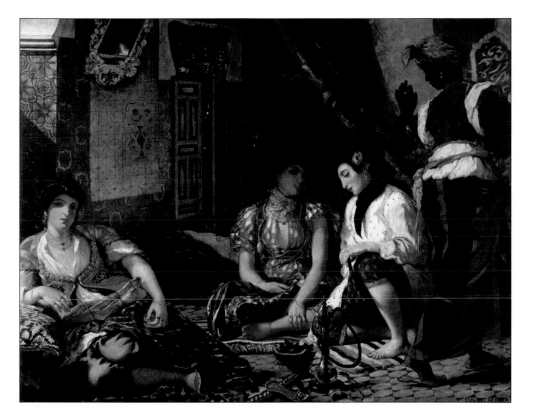

Plate 29

THE NATCHEZ

1835, The Metropolitan Museum of Art, New York City
90.2 x 116.8 cm, Oil on canvas

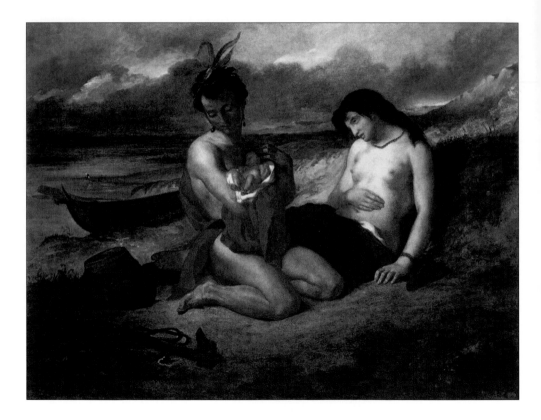

Plate 30

FANATICS OF TANGIER
1837–38, Minneapolis Institute of Arts
95.57 x 128.59 cm, Oil on canvas

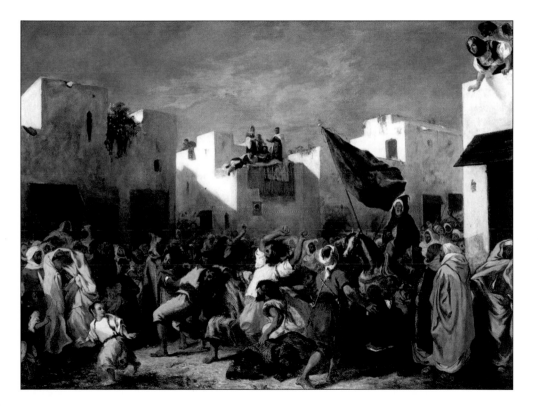

Plate 31

CHRISTOPHER COLUMBUS AND HIS SON
AT LA RÁBIDA

1838, National Gallery of Art, Washington, DC
90.3 x 118 cm, Oil on canvas

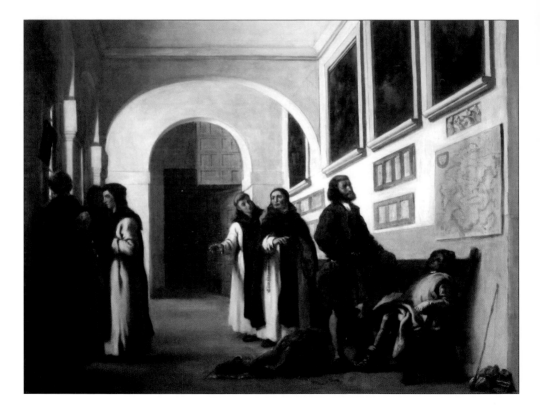

Plate 32

CLEOPATRA AND THE PEASANT

1838, Ackland Art Museum, The University of North Carolina at Chapel Hill
97.8 x 127 cm, Oil on canvas

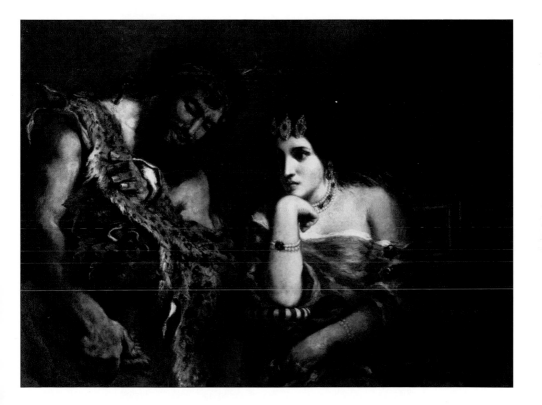

Plate 33

FREDERIC CHOPIN

1838, Musée du Louvre, Paris
45.5 x 38 cm, Oil on canvas

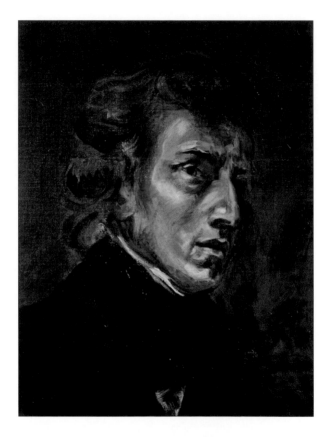

Plate 34

MÉDÉE FURIEUSE

1838, Musee des Beaux-Arts, Lille, France
260 x 165 cm, Oil on canvas

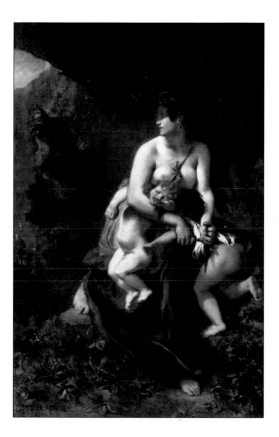

Plate 35

PORTRAIT OF GEORGE SAND

1838, Ordrupgaard, Copenhagen
78 x 56.5 cm, Oil on canvas

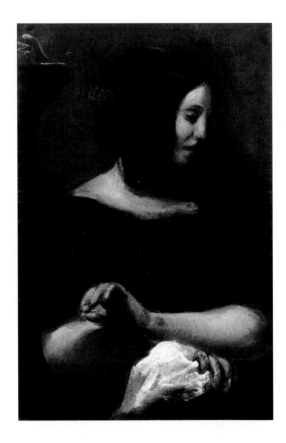

Plate 36

HAMLET AND HORATIO IN THE CEMETERY

1839, Musée du Louvre, Paris
29 x 36 cm, Oil on canvas

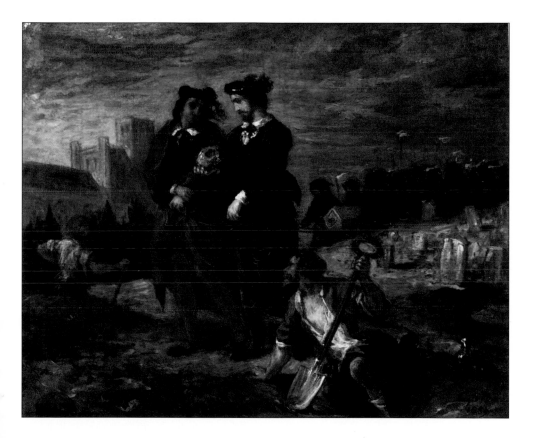

Plate 37

HAMLET AND HORATIO IN THE CEMETERY

1839, Musée du Louvre, Paris
82 x 65 cm, Oil on canvas

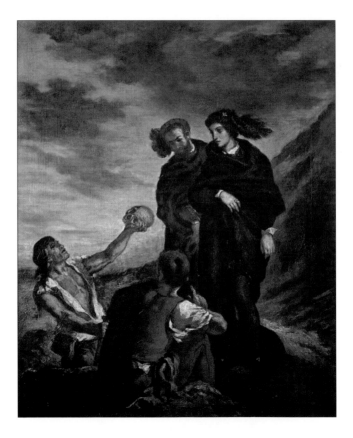

Plate 38

THE CRUSADERS ENTRY INTO CONSTANTINOPLE

1840, Musée du Louvre, Paris
411 x 497 cm, Oil on canvas

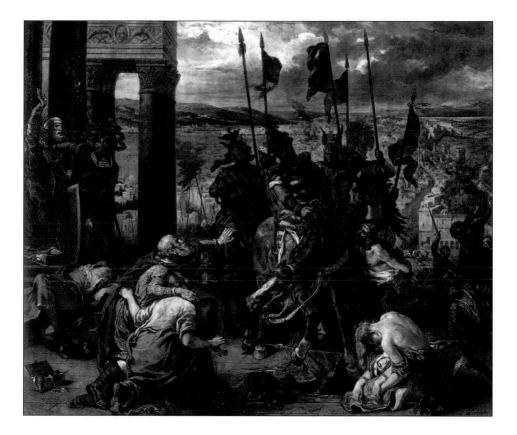

Plate 39

THE SHIPWRECK OF DON JUAN

1840, Musée du Louvre, Paris
135 x 196 cm, Oil on canvas

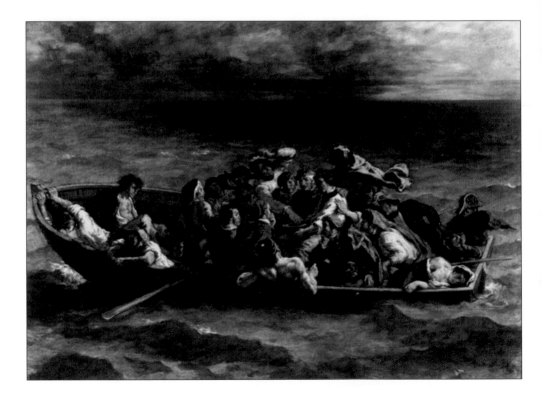

Plate 40

WOUNDED LIONESS
1840–50, Art Institute of Chicago
33.4 x 56.3 cm, Oil on canvas

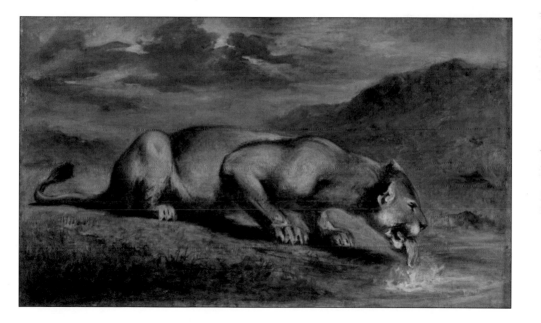

Plate 41

A JEWISH WEDDING IN MOROCCO

1841, Musée du Louvre, Paris
105 x 140.5 cm, Oil on canvas

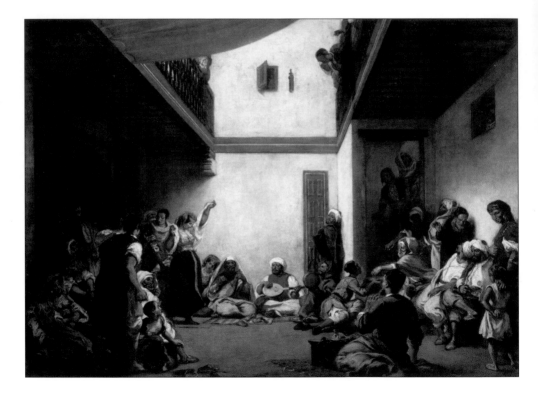

CHRIST ON THE SEA OF GALILEE

c. 1841, The Nelson-Atkins Museum of Art, Kansas City, Missouri
45.72 x 54.61 cm, Oil on canvas

Plate 42

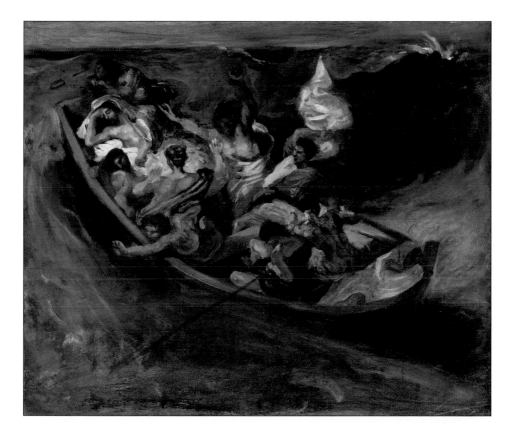

Plate 43

PEASANT WOMEN FROM THE REGION
OF THE EAUX-BONNES

1845, Art Institute of Chicago

34 x 26.2 cm, Watercolor, with gouache, over traces of graphite, on cream wove paper

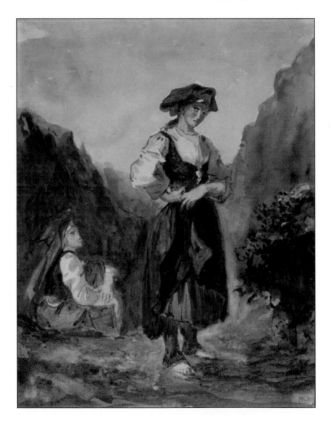

CHRIST ON THE CROSS

Plate 44

1846, The Walters Art Museum, Baltimore, Maryland
80 x 64.2 cm, Oil on canvas

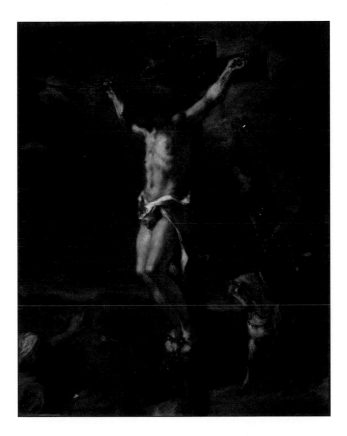

Plate 45

THE ABDUCTION OF REBECCA

1846, The Metropolitan Museum of Art, New York City
100.3 x 81.9 cm, Oil on canvas

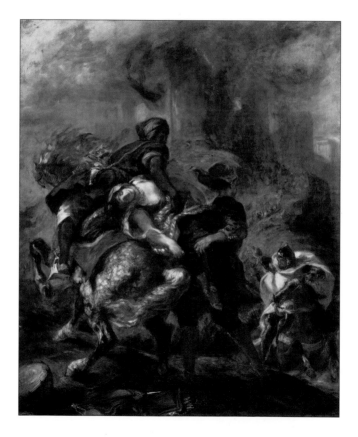

Plate 46

ARABS PLAYING CHESS
1847–49, National Galleries Scotland, Edinburgh
46 x 55 cm, Oil on canvas

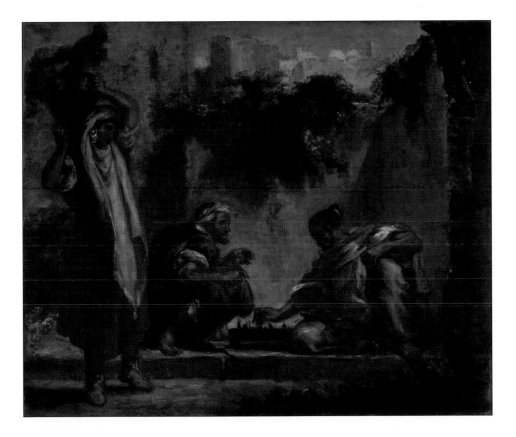

Plate 47

STILL LIFE WITH FLOWERS AND FRUIT
1848, Philadelphia Museum of Art
108.3 x 143.2 cm, Oil on canvas

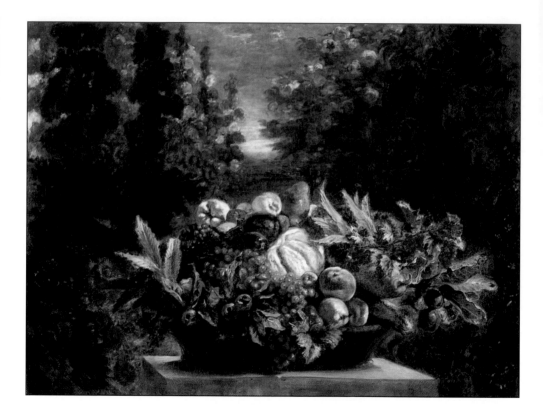

Plate 48

BASKET OF FLOWERS
1848–49, The Metropolitan Museum of Art, New York City
107.3 x 142.2 cm, Oil on canvas

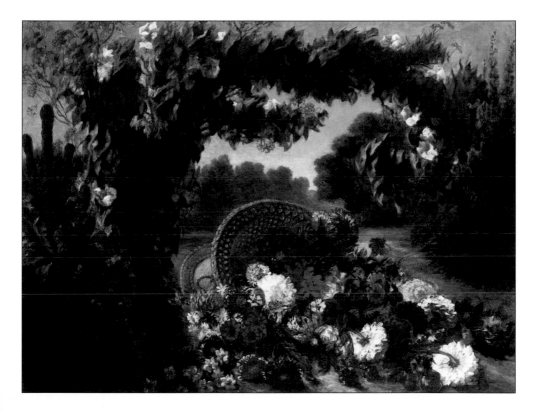

Plate 49

WOMEN OF ALGIERS IN THEIR APARTMENT

1849, Musée Fabre, Montpellier, France
85 x 112 cm, Oil on canvas

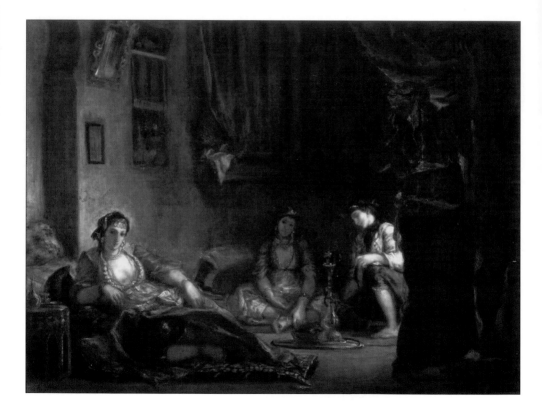

Plate 50

LADY MACBETH SLEEP-WALKING
1849–50, Beaverbrook Art Gallery, Fredericton, New Brunswick, Canada
40.8 x 32.5 cm, Oil on canvas

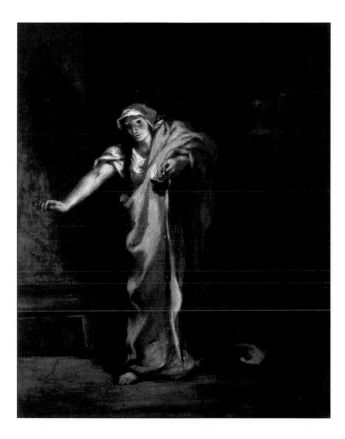

Plate 51

VASE OF FLOWERS ON A CONSOLE

1849–50, Musee Ingres, Montauban, France
135 x 102 cm, Oil on canvas

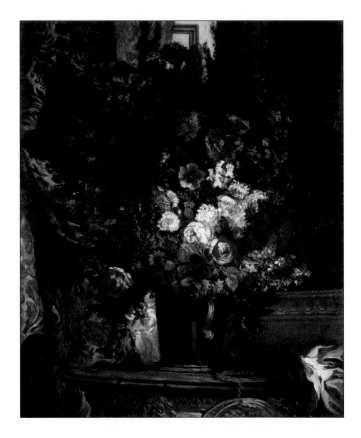

Plate 52

ARAB HORSEMAN GIVING A SIGNAL
1851, Chrysler Museum of Art, Norfolk, Virginia
55.9 x 46.4 cm, Oil on canvas

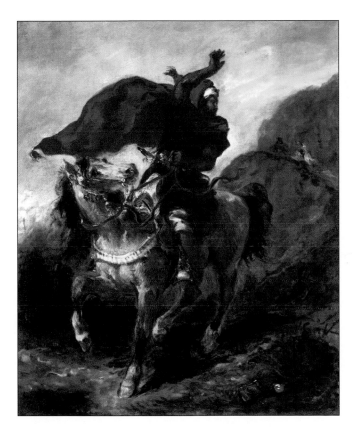

Plate 53

MARPHISE

1852, The Walters Art Museum, Baltimore, Maryland
82 x 101 cm, Oil on canvas

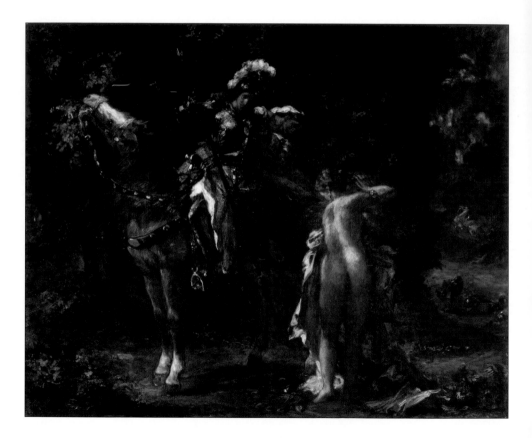

THE EDUCATION OF THE VIRGIN

Plate 54

1852, The National Museum of Western Art, Tokyo
46 x 55.5 cm, Oil on canvas

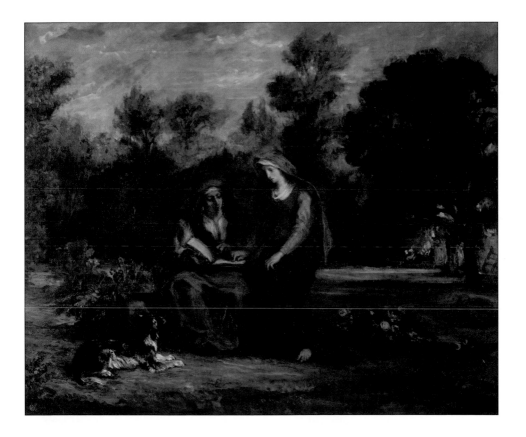

Plate 55
THE SEA VIEWED FROM THE HEIGHTS OF DIEPPE

1852, Musée du Louvre, Paris
36 x 52 cm, Oil on canvas

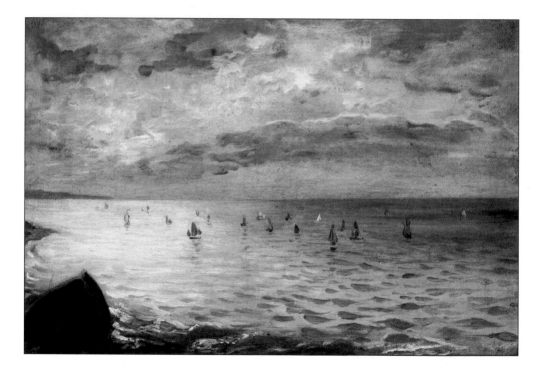

Plate 56

VIEW OF TANGIER
1852–53, Minneapolis Institute of Arts
45.09 x 54.61 cm, Oil on canvas

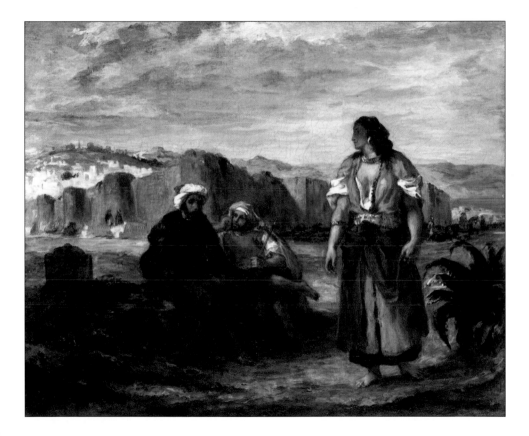

Plate 57

DESDEMONA CURSED BY HER FATHER

1852, Brooklyn Museum, New York City
40.6 x 32.1 cm, Oil on cradled panel

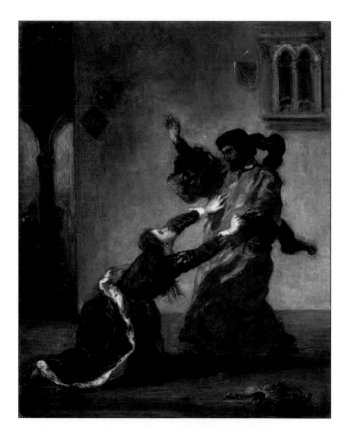

Plate 58

CLIFFS NEAR DIEPPE
1852–55, Musée Marmottan, Paris
20 x 31 cm, Watercolor on paper

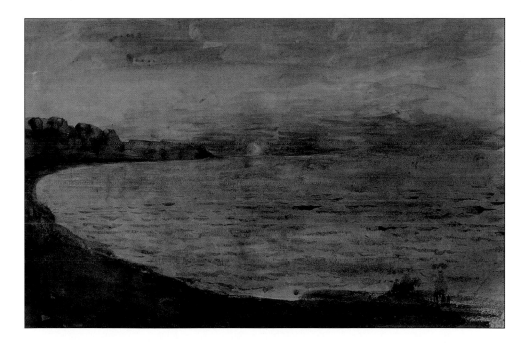

Plate 59

CHRIST ASLEEP DURING THE TEMPEST
c. 1853, The Metropolitan Museum of Art, New York City
50.8 x 61 cm, Oil on canvas

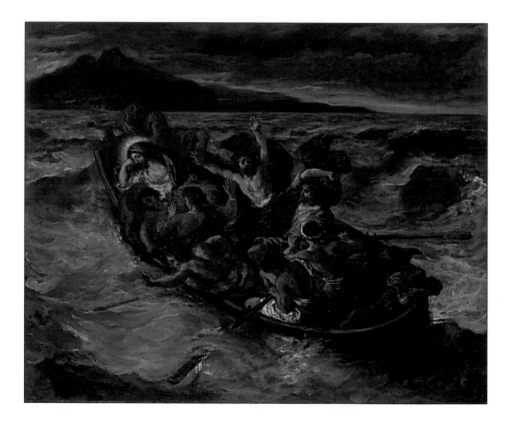

Plate 60

PORTRAIT OF ALFRED BRUYAS

1853, Musée Fabre, Montpellier, France
116 x 89 cm, Oil on canvas

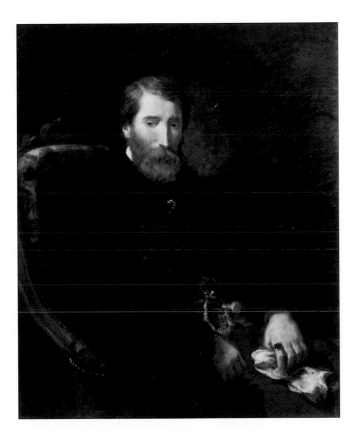

Plate 61

THE DISCIPLES AT EMMAUS

1853, Brooklyn Museum, New York City
55.2 x 47 cm, Oil on canvas

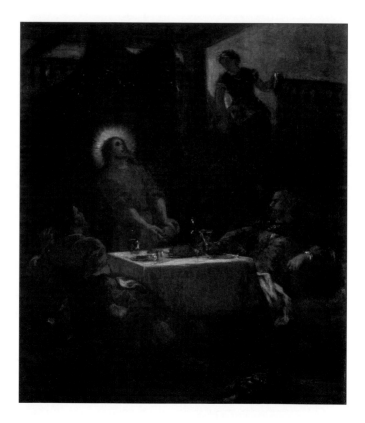

BATHING WOMEN

Plate 62

1854, The Wadsworth Atheneum Museum of Art, Hartford, Connecticut
92.7 x 77.5 cm, Oil on canvas

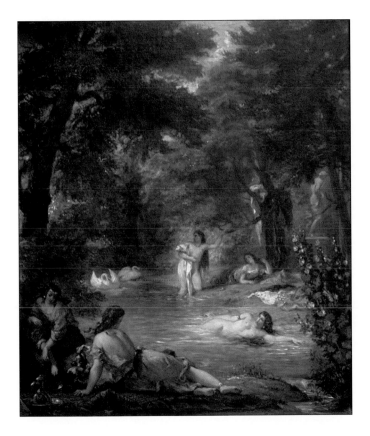

Plate 63

CHRIST ON THE SEA OF GALILEE

1854, The Walters Art Museum, Baltimore, Maryland
59.8 x 73.3 cm, Oil on canvas

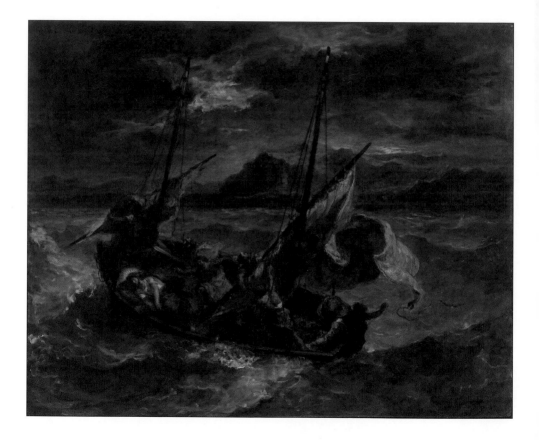

TIGER HUNT
1854, Musée d'Orsay, Paris
73 x 92.5 cm, Oil on canvas

Plate 64

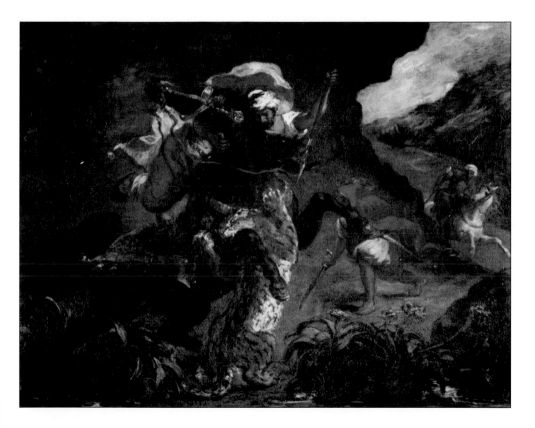

Plate 65

LION DEVOURING A RABBIT

1856, Musée du Louvre, Paris
46.5 x 55.5 cm, Oil on canvas

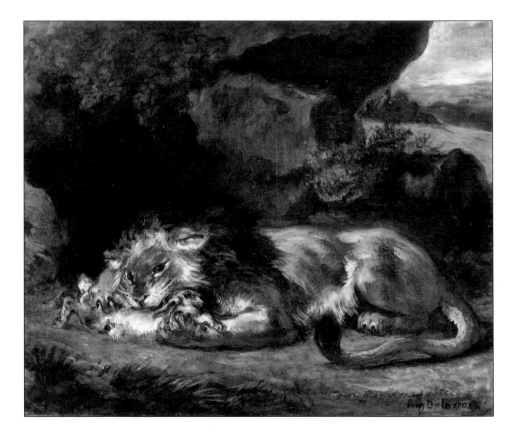

VIEW OF TANGIER FROM THE SEASHORE

Plate 66

c. 1856–58, Minneapolis Institute of Arts
79.53 x 99.85 cm, Oil on canvas

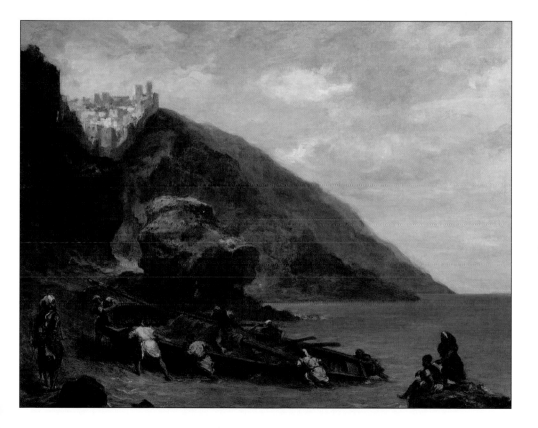

Plate 67

AN ARAB SADDLING HIS HORSE

1857, Museum of Fine Arts Budapest
50 x 61.5 cm, Media not given

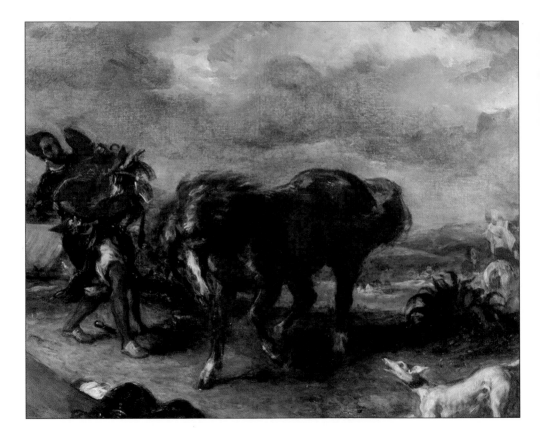

Plate 68

SELIM AND ZULEIKA
1857, Kimbell Art Museum, Fort Worth, Texas
47.6 x 40 cm, Oil on canvas

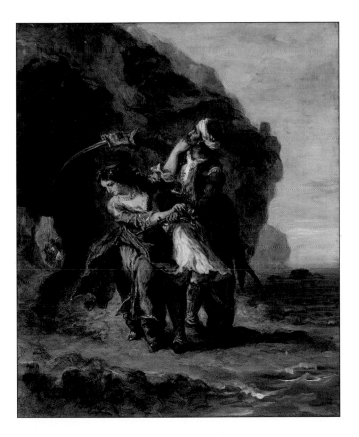

Plate 69

CHRIST CARRIED DOWN TO THE TOMB
1859, The National Museum of Western Art, Tokyo
56.3 x 46.3 cm, Oil on canvas

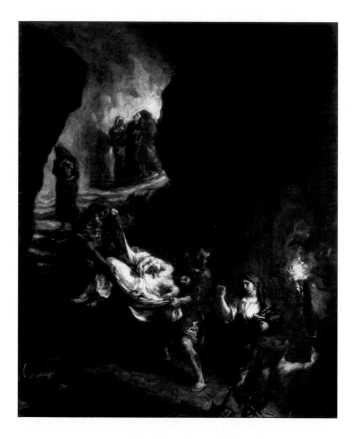

DEMOSTHENES ON THE SEASHORE

Plate 70

1859, National Gallery of Ireland, Dublin
49 x 60 cm, Oil on paper, laid on wood panel

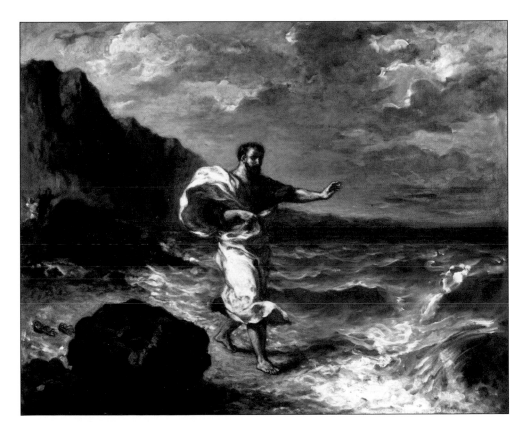

Plate 71

PUMA
1859, Musée d'Orsay, Paris
41.2 x 30.7 cm, Oil on wood

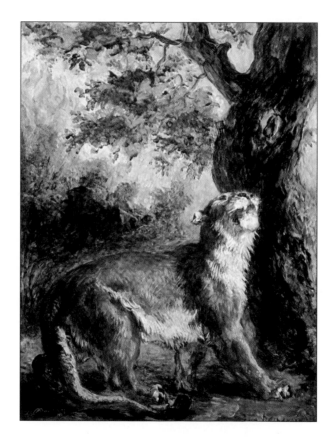

Plate 72

ARAB HORSES FIGHTING IN A STABLE

1860, Musée d'Orsay, Paris
65.5 x 81 cm, Oil on canvas

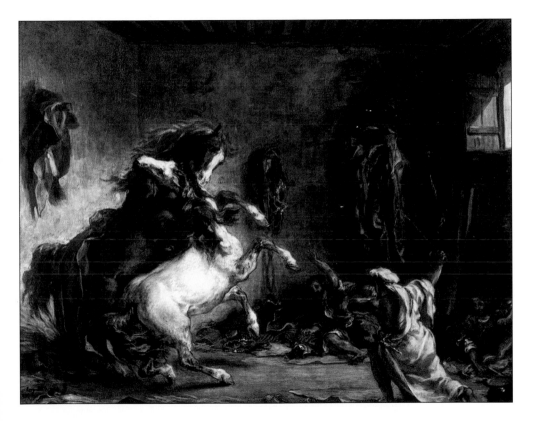

Plate 73

HORSES COMING OUT OF THE SEA

1860, The Phillips Collection, Washington, DC
51.4 x 61.6 cm, Oil on canvas

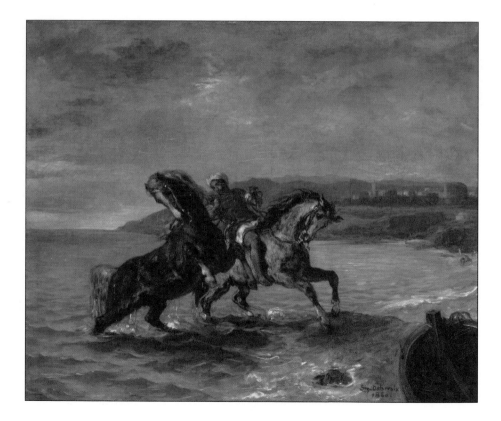

Plate 74

SCENE FROM THE ROMANCE OF AMADIS DE GAULE

1860, Virginia Museum of Fine Arts, Richmond
54.61 x 65.41 cm, Oil on canvas

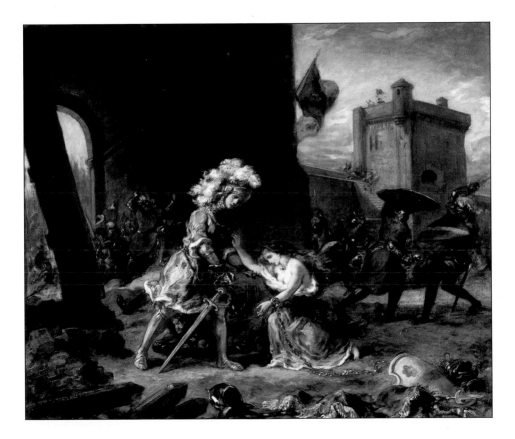

Plate 75

BOTZARIS SURPRISES THE TURKISH CAMP
AND FALLS FATALLY WOUNDED

1860–62, Toledo Museum of Art, Ohio
65 x 73 cm, Oil on canvas

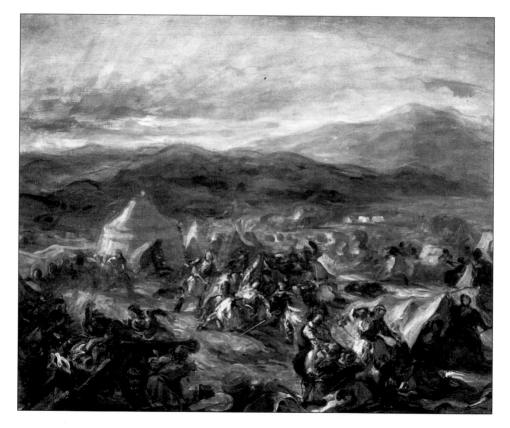

Plate 76

LION HUNT
1861, Art Institute of Chicago
76.5 x 98.5 cm, Oil on canvas

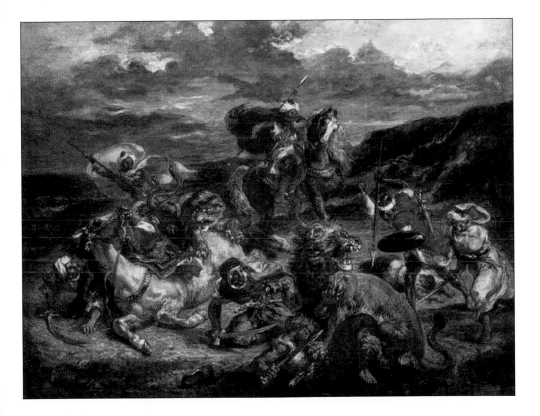

Plate 77

JACOB'S FIGHT WITH THE ANGELS
1861, Church of Saint-Sulpice, Paris
714 x 485 cm, Oil mural

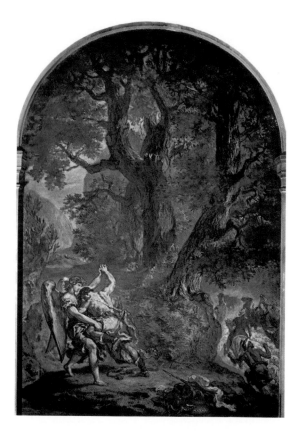

Plate 78

THE EXPULSION OF HELIODORUS
1861, Church of Saint-Sulpice, Paris
714 x 485 cm, Oil mural

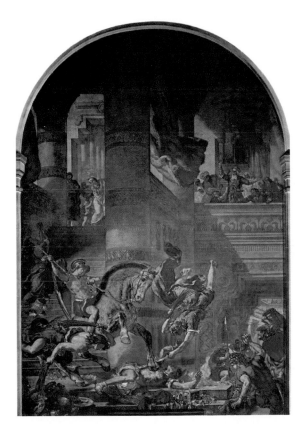

Plate 79

HERCULES AND ALCESTIS
1862, The Phillips Collection, Washington, DC
32.3 x 48.9 cm, Oil on cardboard

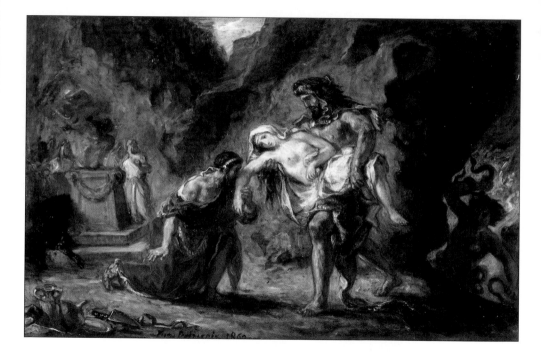

Plate 80

HORSES AT A FOUNTAIN
1862, Philadelphia Museum of Art
73.7 x 92.4 cm, Oil on canvas

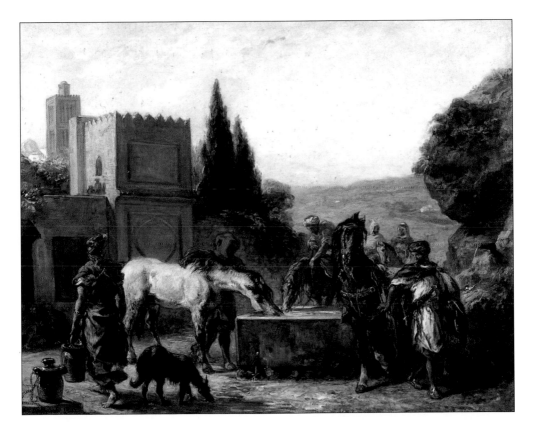

Plate 81

SAINT STEPHEN BORNE AWAY BY HIS DISCIPLES

1862, Barber Institute of Fine Arts, Birmingham, UK
46.7 x 38 cm, Oil on canvas

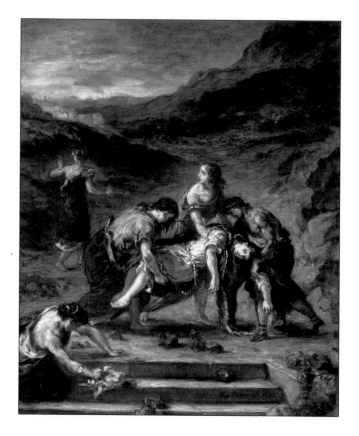

Plate 82

ARABS SKIRMISHING IN THE MOUNTAINS

1863, National Gallery of Art, Washington, DC
92.5 x 74.5 cm, Oil on canvas

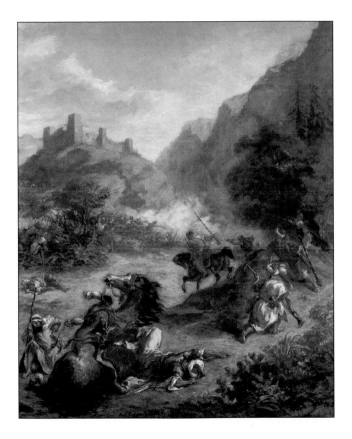

INDEX